European Paintings

in The Metropolitan Museum of Art

A WALKING GUIDE

EDITED BY
Keith Christiansen and Katharine Baetjer

WITH CONTRIBUTIONS BY
Maryan Ainsworth, Andrea Bayer, Alison Hokanson,
Walter Liedtke, Asher Ethan Miller, Xavier Salomon,
and Susan Alyson Stein

The Metropolitan Museum of Art, New York
In association with Scala Publishers

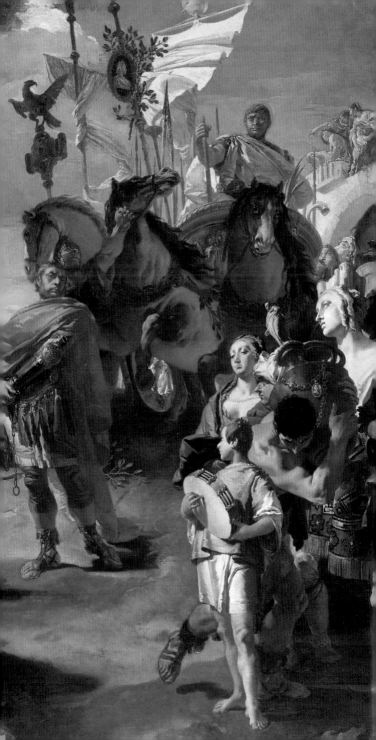

Introduction

The seven itineraries in this pocket guide will take you through The Metropolitan Museum of Art's world-famous collection of European paintings, which numbers more than 2,500 works made over a period of almost seven hundred years, from the 13th to the early 20th century. Arranged with attention to both chronology and geography, the installation provides an overview of painting in Italy, France, Spain, the Netherlands, Belgium, Germany, and Great Britain. The galleries are located on the second floor and divided into two parts, joined by a long corridor for the display of drawings, prints, and photographs. At the top of the Grand Staircase are those devoted to old master painting, from Giotto to Jacques-Louis David and Goya. The Dutch holdings are especially notable, but there are outstanding masterpieces throughout. At the end of the corridor, at the south end of the building, are the galleries for European painting of the 19th and early 20th centuries, including the Museum's celebrated collection of Impressionist and Post-Impressionist art.

The story of European paintings at the Metropolitan begins shortly after the Museum's founding in 1870. What distinguishes the collection from those of the great museums of Europe is that so many of the works were acquired by gift or bequest rather than through the nationalization of princely collections or purchase by the nation. For example, all five paintings by Vermeer entered the Museum through the generosity of individual donors, the first in 1889 and the fifth in 1979, and all but five of the twenty-three Cézannes were given or bequeathed. The collection thus provides not only a panorama of European painting but a history of taste in New York City from 1870 to the present. The credit line that appears on the wall label for each work records the name of the donor and the year of acquisition. A summary history of the collection and its principal donors can be found at the end of this volume.

Thanks to donated funds as well as gifts and bequests, the collection continues to grow, helping the Museum's curators to move into areas of study previously ignored and to fill lacunae with paintings of the requisite quality.

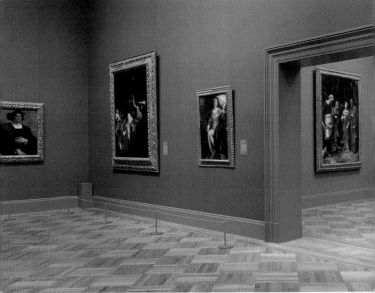

The Venetian 16th-Century Painting gallery (607).

Note: Not all the works pictured in this guide will be on view at any one time, as the Metropolitan Museum contributes to many international exhibitions. Occasional changes in individual galleries are also to be expected.

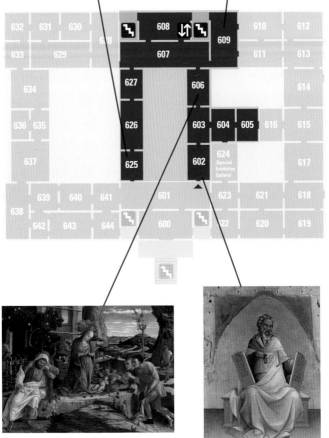

The Renaissance in Italy from Giotto to Titian

GALLERIES 602–609, 625–627

In the early 14th century, Western culture experienced a gradual shift from the monastic world of the Middle Ages to the mercantile, urban world of the city-state—a shift that was fundamental to the creation of modern society. During the Renaissance, portraiture assumed a new prominence, as did allegorical and mythological painting. The civilizations of ancient Greece and Rome became the template for artistic as well as literary, scientific, and intellectual achievement. At the same time, there was an increased tendency to question received opinion and debate critical attitudes. Beginning in the 1430s, Leon Battista Alberti wrote the first treatises since antiquity on painting, sculpture, and architecture, and in 1550 the painter-architect Giorgio Vasari published *Lives of the Artists*, recognizing the newly elevated status of his protagonists, who, in the Middle Ages, had been considered skilled artisans with limited intellectual or creative ambition.

This visit begins in gallery 602.

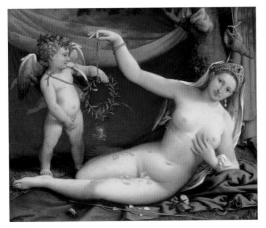

Gallery 607

Giotto and the Pictorial Revolution

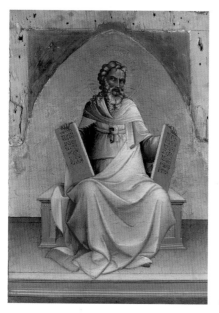

Lorenzo Monaco, *Moses*,
ca. 1408–10

The mercantile republic of Florence transformed European culture
in the 14th century with the poetry of Dante and Petrarch and
with the *Decameron* of Boccaccio. Giotto dominated the period
with his solidly constructed figures and mastery of pictorial space.
As one early writer noted, "Giotto translated the art of painting
from Greek into Latin and made it modern." The transformation
can be appreciated in this gallery by comparing the Byzantine style
of Berlinghiero's *Madonna and Child* from the 1230s with Giotto's
Epiphany of a century later. Tender Madonnas, rugged saints, and
dramatic narrative paintings possess a new humanity relative to
their counterparts in medieval art. The gold backgrounds, carried
over from the previous era, would have come alive when seen by
candlelight. Lorenzo Monaco employed rhetorical gesture and
dazzling color to confer on his Old Testament prophets a grave yet
graceful intensity.

Filippo Lippi to Botticelli

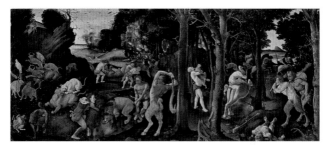

Piero di Cosimo, *A Hunting Scene*, ca. 1507–8

Florentine 15th-century painters such as Filippo Lippi, Domenico Ghirlandaio, and Botticelli asserted their claim to be judged the equal of poets—no longer mere craftsmen. Whether commissioned to paint the Madonna (Filippino Lippi, Luca Signorelli, Fra Bartolomeo), evoke the history of primitive man (Piero di Cosimo), or adorn a church (Fra Carnevale) or private residence (Botticelli's *Last Communion of Saint Jerome*), each employed a cultivated and highly personal style that demonstrated both his particular creative genius and his ability to describe the world around him.

Domestic Art in 15th-Century Florence

Giovanni di ser Giovanni Guidi (called Scheggia),
The Triumph of Fame, ca. 1449

Wealthy Florentine merchants and bankers and members of
prominent families commissioned portraits for posterity.
Marriage was often commemorated with a pair of large storage
chests (*cassoni*) with painted fronts illustrating emblematic
stories from Greek and Roman mythology or the Old Testament.
Marriage chambers might be decorated with painted panels set
into wainscoting and large, ceremonial trays celebrated the
birth of an heir (the Museum owns that of Lorenzo de' Medici,
illustrated here). Sets of ceramic tableware were acquired and
conspicuously displayed. In this gallery, secular art takes its place
alongside religious painting as a mainstay of the artist's world.

Painting and Sculpture for Domestic Interiors

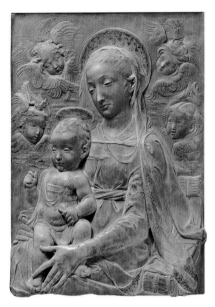

Antonio Rossellino,
Madonna and Child with Angels, ca. 1455–60

In the 15th century, patrons were as likely to commission portrait busts as painted portraits for their palace interiors and as inclined to decorate their bedrooms with sculpted reliefs as with painted images of the Madonna and Child. The great theorist and critic Leon Battista Alberti felt that painting and sculpture were closely related, and Renaissance artists and critics habitually debated the superiority of one relative to the other. Painters emphasized the three-dimensionality of their figures and sometimes simulated sculpture in paint, while sculptors often embellished the surfaces of their marble sculptures with gold and painted decoration. Luca della Robbia famously incorporated color into his glazed terracotta images, and sculptures in wood and terracotta were invariably colored—most commonly by a professional painter. A number of artists practiced both painting and sculpture; the portrait medal was invented by a painter, Pisanello, who invariably signed himself PICTOR ("painter").

The Benjamin Altman Collection

Venice and North Italy in the 15th Century

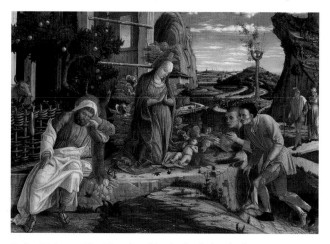

Andrea Mantegna, *The Adoration of the Shepherds*, shortly after 1450

As in Florence, so in Venice and elsewhere in northern Italy painters asserted their claim to be considered the equal of poets. The minutely descriptive style of Andrea Mantegna's *Adoration of the Shepherds*, painted in Padua, posed a real challenge to poets in its variety and affective power, while the sacred figures in the Venetian Giovanni Bellini's devotional paintings radiate a compelling humanity. Also in Venice, Vittore Carpaccio employed his detailed style to create richly programmed images suitable as aids for meditation.

Venetian 16th-Century Painting

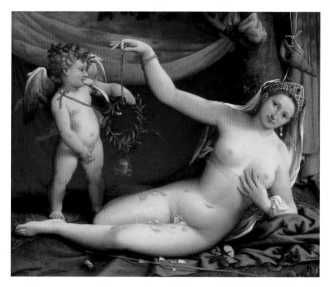

Lorenzo Lotto, *Venus and Cupid*, possibly mid-1520s

Venice may have been in decline as an economic power, but Titian, Veronese, and Jacopo Tintoretto made the 16th century a golden age of Venetian painting. Titian's broadly brushed, sensual nudes broke entirely new ground. He became the preferred painter at the courts of Europe and influenced artists down to Rubens, Velázquez, and Delacroix. Veronese's opulent compositions combined striking naturalistic effects with grandeur and brilliant color (the rich palette of Venetian painting owed much to the city's commercial ties with the Middle East, the source of many pigments). Tintoretto infused unprecedented drama into his paintings, wielding his brush like a pen. Jacopo Bassano explored a modern-seeming intensity of expression by embracing an unfinished (*non finito*) style in his *Baptism of Christ* and other late works. At the same time, there was room for such idiosyncratic geniuses as Lorenzo Lotto—always unpredictable and sui generis.

North Italian 16th-Century Painting

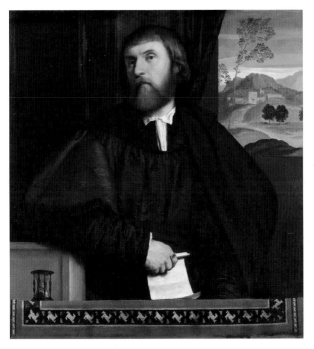

Moretto da Brescia, *Portrait of a Man*, ca. 1520–25

In the 16th century, the northern cities of Milan, Brescia, Parma, Bologna, and Ferrara made crucial contributions to the history of European art, despite their turbulent political histories. The two greatest painters of the region were Parmigianino, an exponent of Mannerism, and Correggio, whose exploration of the world of ecstatic emotion laid the basis for the style we know as Baroque. Moretto da Brescia's insistence on the close study of posed models and nature became a reference point for Caravaggio, who was trained in Milan. Moretto's compatriot and sometime collaborator Girolamo Romanino embraced a raw expressivity much influenced by the engravings of Albrecht Dürer, and Giovanni Battista Moroni was the defining portraitist of the Counter-Reformation.

The R. H. Macy Gallery

Central Italian Painting
of the High Renaissance

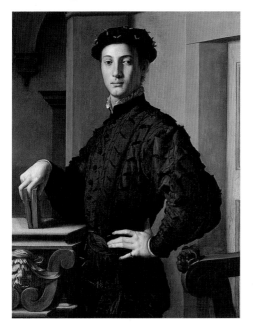

Bronzino, *Portrait of a Young Man*, 1530s

Over the course of the 16th century, Rome replaced Florence
as the center of painting, its cultural patrimony inspiring both
Michelangelo and Raphael. The classical harmony and grandeur
achieved by those two artists influenced all their contemporaries
and remained a model of emulation through the 19th century.
Their counterpart in Florence was Andrea del Sarto, the "painter
without errors" (Vasari). Two defining events were the Sack of
Rome by German troops in 1527—a trauma that reverberated
throughout Europe—and the definitive establishment in Florence
of a princely state under Medici rule in 1537, with Bronzino as its
star portraitist. The end of the century saw an attempt to recapture
the glory of what had come to be seen as a golden age. Study of
the great masters and of nature was the path to success.

The Legacy of Duccio

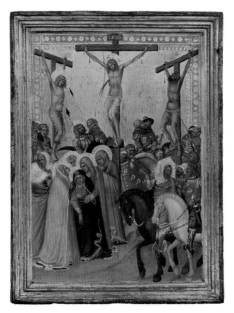

Pietro Lorenzetti, *The Crucifixion*, 1340s

Together with Giotto in Florence, Duccio in Siena was one of the founders of European painting. But his art was concerned less with constructing a rigorously rational space and solid, three-dimensional figures than with exploring a realm of tender emotion and refined color. He was Matisse to Giotto's Picasso. His pupil Simone Martini—whose work combines naturalistic observation with exquisitely elaborated details—followed the papal court to Avignon, where he died in 1344, and thereby extended Duccio's influence throughout Europe. In Sienese art, there is a persistent tension between the rational and irrational; the hyperbeautiful and the grotesque; tenderness and violence. Not surprisingly, the appreciation for Sienese painting is closely allied with the advent of modernism: Giovanni di Paolo has been seen as a precursor of the 20th-century Surrealists.

Gothic Altarpieces and the Art of Devotion

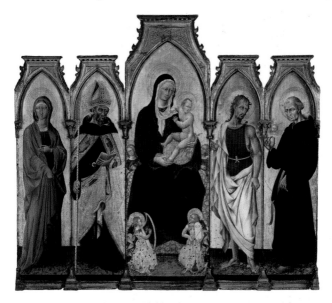

Giovanni di Paolo, *Madonna and Child with Saints*, 1454

Throughout the 14th century and into the 15th, the principal task of a painter was to create a large, multipanel altarpiece for a church or convent. The appearance and structure varied by local tradition. In Italy, an altarpiece would be constructed of individual panels and have pinnacles and a base—as in the architecture of a Gothic cathedral. In Spain, it would be an enormous, multistory construction (*retablo*) that filled the back wall of a church or chapel. In the Netherlands and Germany, it tended to have hinged wings, allowing the center image to be hidden from view except on feast days. Altarpieces were at the core of devotional practice. Lit by candles, they served as the backdrop for the performance of mass, their beauty enhanced by instrumental and vocal music. Devotional art aimed to connect viewers with a sacred realm and to remind them of those who had died for their faith in ages past. Many of the individual panels in the Museum's collection are fragments of altarpieces.

North Italian Gothic Painting

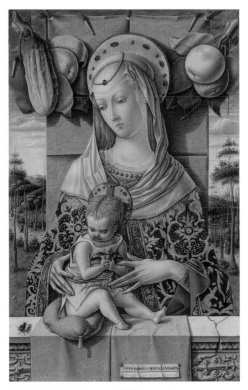

Carlo Crivelli, *Madonna and Child*, ca. 1480

The centers of North Italian painting were Milan, Venice, Bologna, and Ferrara. Venice aside, the art of each of these schools was an art of the courts, with a premium placed on rich surface treatment, naturalistic details, and elegance. The defining mediums were goldsmith's work and illuminated manuscripts, from which paintings often borrowed their aesthetic. A self-conscious style modeled on the prevailing intricacy of literary description was highly valued. Only gradually over the course of the 15th century did the Renaissance sensibility forged in Florence, with its emphasis on the imitation of classical art, gain the upper hand.

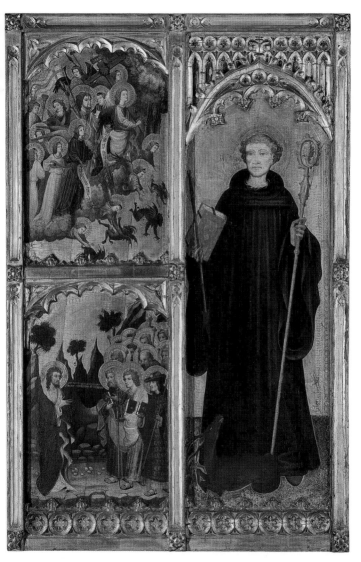

Miguel Alcañiz, *Saint Giles with Christ Triumphant over Satan and the Mission of the Apostles*, ca. 1420. Gallery 626

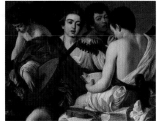

		632	631	630			608	↑↓			610		612
				628				609				611	613
		633	629			607							
					627		606						614
		634											
636	635		626		603	604	605	616	615				
	637		625		602	624 (Special Exhibition Gallery)			617				
	639	640	641	601		623	621	618					
638				600	622	620	619						
	642	643	644										

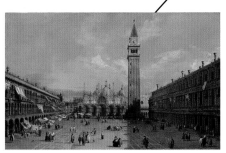

Italian Painting from Caravaggio to Tiepolo

GALLERIES 600, 601, 618–623

2

Throughout the 17th century, Rome was the undisputed religious and artistic center of Europe, and the patronage of popes, cardinals, and aristocrats was essential for painters. At the Council of Trent (1545–63), the Catholic Church, keen to counteract the spread of Protestantism, had issued stricter rules for the production of paintings, promoting an interest in the history and traditions of the early Church and a closer attention to naturalism. This moment culminated in the work of Caravaggio. With the papacy of the culturally ambitious Urban VIII Barberini (ruled 1623–44), art embraced an ebullient spirit, whether treating religious or mythological subjects. Urban also promoted the new musical form of opera. In the 18th century, Venice vied with Rome as the leading artistic and musical capital, becoming an international tourist destination. The art of Canaletto and Giovanni Battista Tiepolo embodied the sophisticated temper of this pleasure-loving city.

This visit begins in gallery 601.

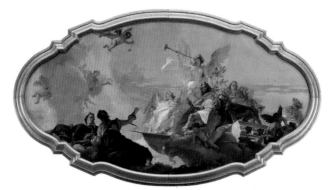

Gallery 600

Baroque Painting in Italy

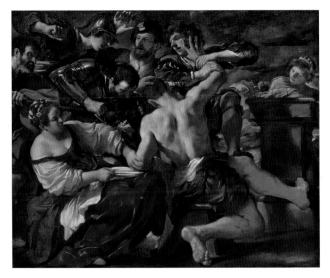

Guercino, *Samson Captured by the Philistines*, 1619

At the end of the 16th century, artists such as Scipione Pulzone responded to the religious shift of the Counter-Reformation with profoundly pious works. Over the next fifty years, altarpieces developed into the lavish canvases of Guido Reni and Guercino. Cardinals and princes competed to decorate their churches and palaces with vibrantly painted, often theatrically staged pictures that treated subjects from the Bible, on the one hand, and ancient history or mythology, on the other. Altarpieces and gallery pictures shared a monumental format and grandiosity of composition. Antiquity, especially classical sculpture, was an important influence on artists such as Andrea Sacchi. In this period and after, Italy continued to assert its central position in European art.

The Carracci and 17th-Century Easel Painting

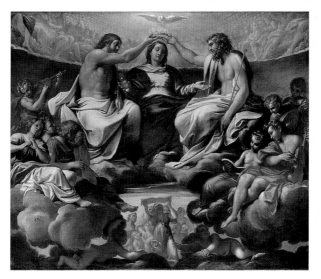

Annibale Carracci, *The Coronation of the Virgin*, after 1595

Annibale Carracci's move from Bologna, where he and his cousin Ludovico had founded a painting academy, to Rome in the 1590s had a momentous impact on Italian art. In Rome, Annibale became fascinated with ancient sculpture and absorbed the work of Raphael and Michelangelo. He undertook large-scale fresco projects but also made easel paintings, mostly of religious subjects. Out of his well-organized workshop came some of the period's most significant painters, including Domenichino and Francesco Albani. Displayed in this gallery, in addition to oil paintings on canvas, are small-scale works, often on copper, produced for important Italian patrons by Carracci, his followers, and others.

Caravaggio and Southern Italy

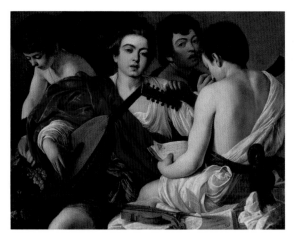

Caravaggio, *The Musicians*, ca. 1595

Born near Bergamo, in northern Italy, Caravaggio trained in Milan and moved to Rome around 1592. Once there, he reinterpreted north Italian models to achieve a new and unique approach to naturalism, producing paintings mostly for aristocratic patrons. His dramatic lighting and expressive intensity had a profound impact on his followers and on European art in general. Between 1606 and 1610 he worked in Naples, Malta, and Sicily, where his style was extremely influential on succeeding generations of artists. Southern painters such as Massimo Stanzione, Artemisia Gentileschi, and Mattia Preti responded in distinctly individual ways to Caravaggio's bold lessons.

Landscape Painting and Claude Lorrain

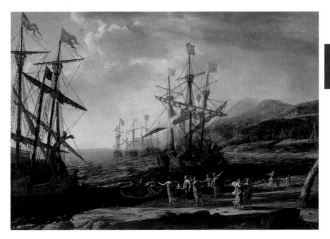

Claude Lorrain, *The Trojan Women Setting Fire to Their Fleet*, ca. 1643

2

Landscape painting developed in Rome, following the examples of Annibale Carracci and his school and of northern European artists who traveled to the city. During the first half of the 17th century, a significant group of foreign artists was based in Italy, painting landscapes for local and international patrons. The most lyrical of these works were by the French artist Claude Lorrain, who lived in Rome for most of his life and painted scenes from ancient history, mythology, and the Bible set in the beautifully observed and luminous surrounding countryside, the Roman Campagna.

The Harry Payne Bingham Galleries

Venetian View Painting

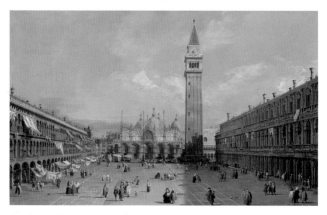

Canaletto, *Piazza San Marco*, late 1720s

In the 18th century, Venice was principally a place of entertainment, with flourishing opera houses, theaters, and publishers. Tourists from Europe visited the city and returned home with works by prominent Venetian artists. Painting reached a peak of virtuosity and was a major export commodity. While Canaletto and Guardi celebrated the fabled beauty of this most magical of cities, Pietro Longhi cast an ironic eye on the amusements and vices of those living behind its noble palace facades. Other artists, such as Sebastiano Ricci and Jacopo Amigoni, concentrated on religious and mythological subjects.

The Lore Heinemann Gallery
The Harry Payne Bingham Galleries

Rome and Naples in the 18th Century

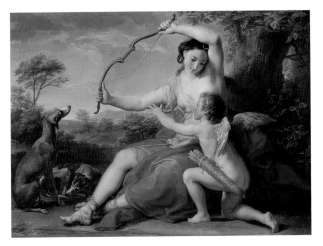

2

Pompeo Batoni, *Diana and Cupid*, 1761

In Rome, artists catered to Englishmen and others making the Grand Tour with spectacular portraits (the most beautiful examples are by Pompeo Batoni), mythologies, and view paintings. Visitors could also return with their memories of ancient and modern Rome captured in canvases such as the pair in this gallery by Giovanni Paolo Panini. It was an era of archaeological discoveries and of renewed interest in the ancient world. Pierre Hubert Subleyras, Corrado Giaquinto, and Francesco Trevisani decorated the city's churches with altarpieces and its palaces with religious paintings. In Naples, by contrast, Gaspare Traversi depicted genre scenes with comic undercurrents.

The Harry Payne Bingham Galleries

Giovanni Battista Tiepolo: Oil Sketches

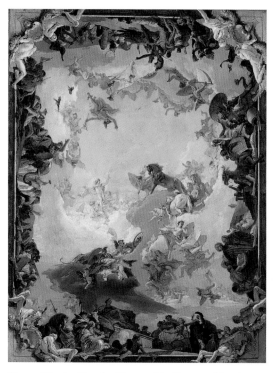

Giovanni Battista Tiepolo, *Allegory of the Planets and Continents*, 1752

Giovanni Battista Tiepolo's fame and consummate skill brought him to work outside Italy, for ecclesiastic and royal patrons in Germany and Spain. On view in this gallery are dazzlingly vertiginous oil sketches for some of his most celebrated projects, including the fresco decoration of the immense ceiling of the staircase in the Residenz, Würzburg, and ceilings in the newly built Palacio Real in Madrid. His son, Giovanni Domenico, preferred less exalted subjects, such as the enchanting *Dance in the Country* of about 1755.

The Harry Payne Bingham Galleries

Giovanni Battista Tiepolo

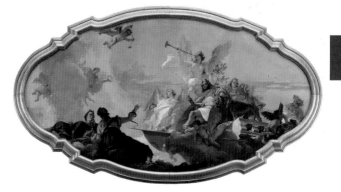

Giovanni Battista Tiepolo, *The Glorification of the Barbaro Family*, ca. 1750

Three enormous canvases by Tiepolo greet visitors to the Metropolitan Museum's galleries of European paintings at the top of the Grand Staircase. These theatrical compositions celebrating victories of ancient Roman generals enthralled guests in the palace of the Dolfin family in Venice in the later 1720s. Blessed with a fecund imagination and matchless technical virtuosity, Giovanni Battista Tiepolo brought to a close the great age of Venetian painting that had begun in the Renaissance with Giovanni Bellini, Giorgione, and Titian. The Metropolitan owns the most important collection of Tiepolo's work outside Venice, including the canvas for the ceiling of the Ca' Barbaro in Venice and frescoes from the Palazzo Valle-Marchesini-Sala in Vicenza.

Dr. Mortimer D. Sackler and Theresa Sackler Gallery

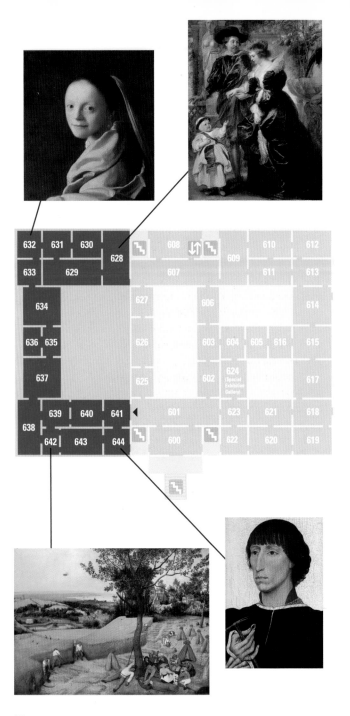

632	631	630			608			610	612	
633		629	628		607	609		611	613	
	634			627		606			614	
636	635			626		603	604	605	616	615
	637			625		602	624 (Special Exhibition Gallery)			617
638	639	640	641		601		623	621	618	
	642	643	644		600		622	620	619	

Northern Painting from Van Eyck to Reynolds

GALLERIES 628–644

3

During this period (about 1420 to 1800), painting flourished in the Burgundian and Spanish Netherlands (modern Belgium), the Dutch Republic, and England. In the 1400s, painting remained mostly religious in subject, although portraits were also in demand. Subsequently, secular concerns and Protestant opposition to devotional imagery brought landscape, still-life, and genre painting to the fore, above all in Holland after 1600. The advance of urban culture, which produced middle-class as well as noble patrons, and the resurgence of the Catholic Church in the Habsburg territories (Belgium) were fundamental factors in nurturing the arts. Rembrandt van Rijn's religious and mythological pictures were acquired by private individuals, but in Peter Paul Rubens's Antwerp, the major clients were Church and State. Rubens was sought out by monarchs across Europe. English painters of the 18th century produced superb individual and group portraits for an increasingly diverse clientele.

This visit begins in gallery 641.

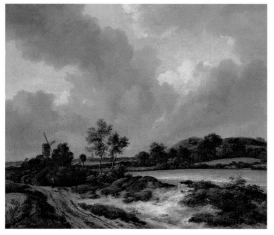

Gallery 638

Jan van Eyck and His Influence

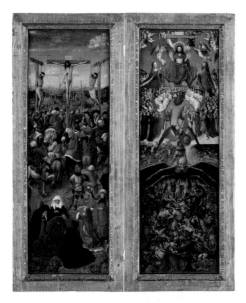

Jan van Eyck
and Workshop
Assistant, *The
Crucifixion and
the Last Judgment*,
ca. 1435

The technique of oil painting, with its aesthetic and practical
advantages over fresco and tempera, transformed European art in
the early 15th century. Jan van Eyck, working in the Burgundian
Netherlands for Duke Philip the Good and other aristocratic clients,
was the technique's most eloquent practitioner. Whether
painting portraits or religious themes, Van Eyck achieved a new
level of realism through his acute powers of observation and
unsurpassed representational technique. His *Crucifixion* of ca.
1435, seen in this gallery, transposed a biblical event into the
viewer's immediate realm of experience and elicited a new kind
of emotional response. Van Eyck's legacy lived on not only in
Bruges, through the works of Petrus Christus, Hans Memling,
and Gerard David, but also more widely in western Europe, where
Netherlandish painting in general was strongly influential.

Key examples are also found in the Museum's Robert Lehman
Collection, Linsky Collection, and at the Cloisters.

Bruges as an Artistic Center

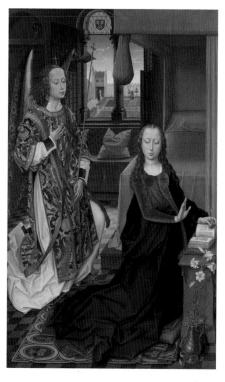

3

Hans Memling,
The Annunciation,
ca. 1465–75

In the 15th century, Bruges was an economic hub of western
Europe and the favored residence of the dukes of Burgundy. The
concentration of wealth, power, and prestige in Bruges attracted
immigrant painters, including Hans Memling, from Seligenstadt,
near Frankfurt, Germany, and Gerard David, from Oudewater,
near Gouda, Holland. In this gallery, the style of these masters and
their workshops can be compared to that of painters who remained
farther north, such as Hieronymus Bosch in s'Hertogenbosch
and Cornelis Engebrechtsz in Leiden. Works by Netherlandish
artists were in great demand in Italy and Spain. Some painters—
such as Juan de Flandes, who was enticed to work for Queen
Isabella the Catholic in Burgos, Spain—left Flanders and eventually
adapted to prevailing local style.

New Developments in Antwerp and Brussels

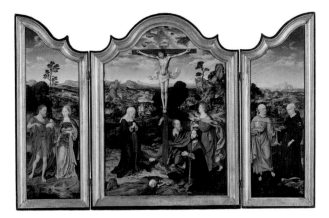

Joos van Cleve and Collaborator, *The Crucifixion with Saints and a Donor*, ca. 1520

At the dawn of the 16th century, Antwerp eclipsed Bruges in economic prestige and power. In response to the newfound wealth of the upper middle class, artists increasingly worked for the open market as well as for aristocratic and ecclesiastical patrons, organizing their workshops to accommodate growing demand. Painters began to specialize in different genres and sometimes collaborated on compositions, with one artist supplying the landscape and another the figures. While Adriaen Isenbrandt stayed on in waning Bruges, Joos van Cleve and Quentin Metsys heralded the prominence of Antwerp, and Bernard van Orley made his career as a painter and tapestry designer in Brussels.

Diverse Approaches to Early Portraiture

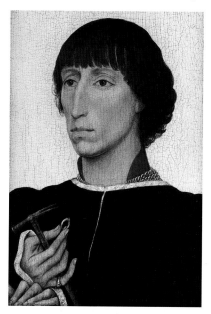

Rogier van der Weyden,
Francesco d'Este, ca. 1460

3

Portraits were commissioned in northern Europe in the 15th and early 16th centuries for a variety of reasons, most often to record an individual's appearance for posterity. But they also served other functions: to represent the sitter's piety, to impart an impression of stature or position in society, or to further political ambitions. The most gifted painters of the period achieved these objectives through their handling and execution, reaching a high level of verisimilitude that not only depicted the sitter's physiognomy but also conveyed a sense of inner life—of the soul.

The Benjamin Altman Collection

Renaissance Painting in Germany

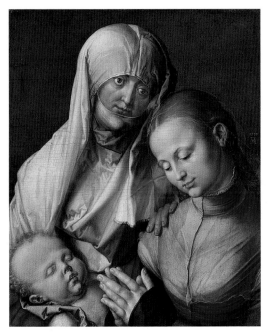

Albrecht Dürer, *Virgin and Child with Saint Anne*, probably 1519

The first third of the 16th century produced some of Germany's most important artists. The Metropolitan Museum owns key examples by Albrecht Dürer, Hans Baldung Grien, Lucas Cranach the Elder, and Hans Holbein the Younger. Having absorbed the realism of early Netherlandish painting and the culture of Italian classicism and humanism, German painting was subsequently transformed by the religious reforms of Martin Luther (1483–1546). Styles varied from region to region. Among the key patrons were the dukes of Saxony and the powerful bishops of the Catholic Church. Commissions from the merchant class led to some of the greatest portraits ever produced, especially those by Holbein, who also worked in England at the court of Henry VIII (ruled 1509–47).

C. Michael Paul Gallery

Patinir, Bruegel, and Landscape Painting

Pieter Bruegel the Elder, *The Harvesters*, 1565

3

Beginning with Jan van Eyck in the 15th century, landscape played an important role in the painting of the Burgundian-Habsburg Netherlands. It was not until about 1515, however, when Joachim Patinir focused his creative energies on panoramic views, rocky vistas, and expansive horizons, that the genre came into its own. Pieter Bruegel the Elder further revolutionized Patinir's vision by producing a brilliantly integrated and harmonious secular universe, where the religious pretext for landscape was all but abandoned. His landscapes are imbued with a new humanism, at once idyllic and vernacular—setting the stage for the development of 17th-century Flemish and Dutch landscape painting.

Ruisdael and Dutch Landscape Painting

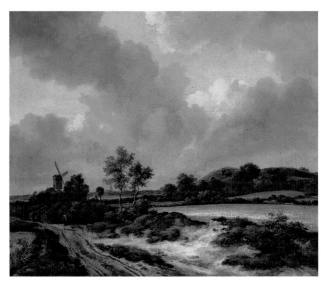

Jacob van Ruisdael, *Grainfields*, mid- to late 1660s

The 17th century in Holland inaugurated the great tradition of
European landscape painting. Works by the best-known Dutch
artists—Jacob van Ruisdael, his Amsterdam follower Meyndert
Hobbema, and Aelbert Cuyp in Dordrecht—were highly prized
by collectors in England and France after 1700 and greatly
influenced 19th-century painters in both Europe and America.
Haarlem was the center of naturalistic landscape painting from
about 1600 to 1650, with masters such as Jan van Goyen and
Salomon van Ruysdael depicting Dutch scenes that often had
a local or nationalistic significance. In other cities, especially
Amsterdam and Utrecht, views of foreign topography, untamed
nature, and pastoral countryside served as psychological relief
from city life in Europe's most urbanized society.

Rembrandt and Hals

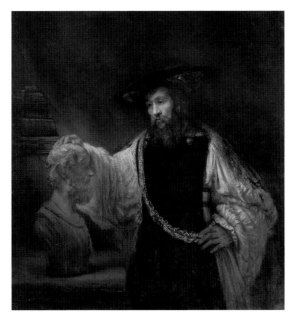

Rembrandt, *Aristotle with a Bust of Homer*, 1653

3

Rembrandt van Rijn and Frans Hals specialized in portraiture, Hals almost exclusively from the late 1620s on; earlier, he had also painted genre subjects in his hometown of Haarlem. During the same decade, the Leiden native Rembrandt concentrated on religious and mythological scenes, which, like his later treatments of such themes, are remarkable for their rethinking of traditional subjects in human terms. *Man in Oriental Costume* of 1632 is among the pictures that announced Rembrandt's arrival in the great port of Amsterdam, where he quickly established himself as a preeminent painter, draftsman, etcher, and teacher. *Aristotle with a Bust of Homer* was commissioned by a Sicilian nobleman in 1653 and is one of the artist's most celebrated works. Paintings by Rembrandt and Hals are also displayed in the Altman Collection (gallery 634). The Metropolitan Museum has the most extensive holdings of both artists' work outside Europe.

Still-Life Painting in Northern Europe

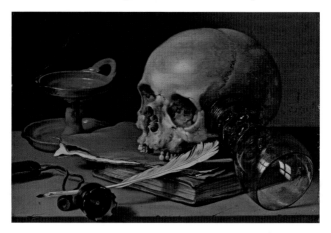

Pieter Claesz, *Still Life with a Skull and a Writing Quill*, 1628

Still-life motifs occur frequently in early Netherlandish art, but the subject flourished as an independent genre after 1600, not only in Dutch and Flemish cities but throughout Europe. Especially in the increasingly urbanized society of Holland and Flanders there was an emphasis on personal possessions, imported goods, hobbies, and learning. Early in the century, flower still lifes were favored by cultivated collectors for their refined execution, natural beauty, and symbolism. The so-called monochrome breakfast, or banquet, painting, with its restrained palette, was more common in the mercantile city of Haarlem, where Pieter Claesz and Willem Claesz Heda worked. Although many Dutch still lifes had moral messages, these were often merely intellectual embellishments in pictures meant primarily to delight and impress viewers with their verisimilitude. German and French still-life paintings usually had Netherlandish sources, but by 1700 the field had become international, with artists moving among foreign cities and courts.

Dutch Decorative Arts

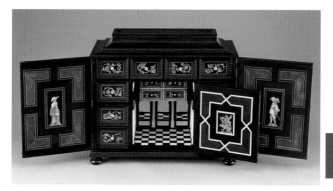

Cabinet, attributed to Herman Doomer, ca. 1640–50

3

The 17th century was the golden age not only of Dutch painting but also of Dutch decorative arts. Attracted by the growing wealth of the republic, artists from the Spanish Netherlands and Germany stimulated local craft traditions and introduced new techniques, including ebony carving and damask weaving. Dutch dominance in overseas trade affected the appearance of luxury furnishings for the homes of wealthy merchants and patricians. Imported Asian porcelain, lacquer, and raw materials such as mother-of-pearl and tropical wood influenced potters and cabinet-makers. Tin-glazed earthenware was decorated to imitate blue-and-white Chinese porcelain, and exotic veneers were used to embellish furniture. The Doomer cabinet, with its understated ebony exterior and spectacular interior, reflects both prevailing standards of superb workmanship and, in its avoidance of outward ostentation, Calvinist sensibilities.

Dutch Paintings in the Altman Collection

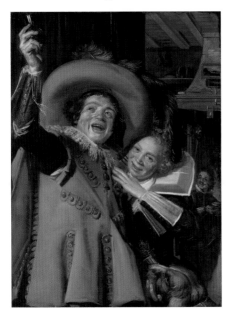

Frans Hals, *Young Man and Woman in an Inn*, 1623

Benjamin Altman (1840–1913) was a New York department store magnate who, in little more than a decade of activity, became one of the greatest collectors in American history. Beginning in 1905, he purchased works by masters ranging from Botticelli and Memling to Velázquez, Vermeer, and, especially, Rembrandt. His paintings may be found in the Metropolitan's Italian, early Netherlandish, Flemish, and Spanish galleries, and he also made extensive bequests to the departments of Asian Art and European Sculpture and Decorative Arts. His collection of Dutch painting was particularly strong and is shown largely intact in this gallery. Two major genre pictures by Hals strike a comic tone that contrasts with the dignified portraits preferred by other Gilded Age collectors. In the field of Dutch landscape, Altman followed conventional taste, purchasing one outstanding picture each by Ruisdael, Hobbema, and Cuyp.

Evelyn Borchard Metzger Gallery
The Benjamin Altman Collection

Dutch Genre Painting

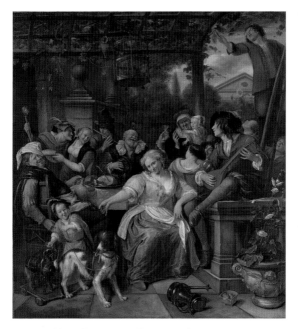

Jan Steen, *Merry Company on a Terrace*, ca. 1670

3

In the 18th century, the French term *genre* covered all types of painting that did not conform to the elevated themes of history, religion, and mythology. Eventually, it came to be applied solely to pictures of "everyday life." Far from being casual depictions of urban or domestic activities, Dutch genre paintings frequently commented on human nature or societal norms, sometimes drawing on sources from the previous century, such as works by Pieter Bruegel the Elder and his contemporaries. After about 1650, collectors in the newly independent, peaceful, and prosperous Dutch Republic favored scenes of middle- and upper-class society. Fashionably dressed women in fine interiors are courted by (mostly) well-mannered men or are discovered alone—as in many paintings by Gerard ter Borch and Johannes Vermeer. Even the rowdier themes of earlier decades take on a more polished veneer.

Vermeer and His Contemporaries

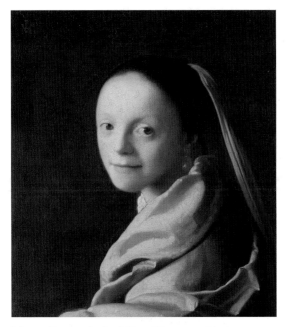

Johannes Vermeer, *Study of a Young Woman*, ca. 1665–67

Johannes Vermeer worked for a small and sophisticated circle of patrons, mainly in his native Delft and in the nearby court city of The Hague. His domestic themes and unusually convincing, yet poetic, treatment of light may create the impression of a straightforward transcription of reality, but, in fact, he explored the traditions established by other genre painters, employing precisely poised designs to depict a world more perfect than the one he actually knew. There are only thirty-six known paintings by Vermeer in the world, and the Museum's exceptional collection of five works covers most of the artist's career and includes two of his most famous genre pictures as well as the unique *Allegory of the Catholic Faith* of about 1670–72. Also shown here are interior scenes by some of Vermeer's outstanding contemporaries, including Pieter de Hooch and Gerard ter Borch.

Dutch History Painting

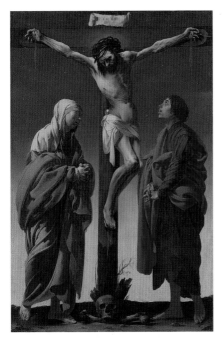

Hendrick ter Brugghen,
*The Crucifixion with the
Virgin and Saint John*,
ca. 1624–25

History painting (embracing religious and mythological subjects
as well as history per se) was the artist's supreme task in the
academies of Europe, especially those of France, Italy, and Spain.
Many Dutch artists also aspired to be history painters, particularly
in Utrecht and in Rembrandt's circle in Amsterdam, and this
gallery contains examples of their work. Hendrick ter Brugghen,
like other artists from Utrecht, traveled to Rome and brought a
version of Caravaggio's style (and his genre subjects) back to the
Netherlands. However, Ter Brugghen's *Crucifixion* of ca. 1624–25
is a special case: it revives the expressive forms of older devotional
works to suit its function as an altarpiece for a Catholic church
(Catholics were tolerated in Holland but met clandestinely).
Dutch history pictures came later to American collections and
with landscapes and genre scenes offer a broader view of Dutch
culture than was understood in the past.

Rubens and Van Dyck

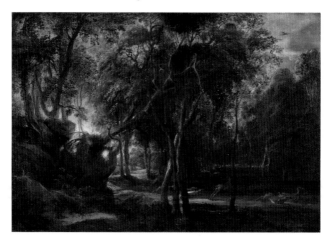

Peter Paul Rubens, *A Forest at Dawn with a Deer Hunt*, ca. 1635

In comparison with the grand works displayed in gallery 628, this gallery features smaller paintings by Peter Paul Rubens, Anthony van Dyck, and other 17th-century Flemish masters. Some are finished paintings suitable for private collectors; some are informal studies—records of live models who reappear in larger canvases; and still others are compositional studies for important public or royal commissions. *The Feast of Acheloüs*, a highly finished collaboration between Rubens and his colleague Jan Brueghel the Elder, is a "cabinet picture," destined for a collector's special room, or "cabinet," where rarities of art and nature were displayed. Van Dyck's *Saint Rosalie* was painted for a prominent collector in Palermo, Sicily, while his later *Virgin and Child with Saint Catherine of Alexandria* could have gone just as easily to a church in the Spanish Netherlands as to a private client. The dramatic landscape by Rubens was painted for his own pleasure.

Stephen C. Clark Gallery

Rubens and Van Dyck

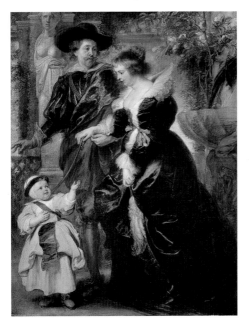

Peter Paul Rubens, *Rubens, His Wife Helena Fourment, and One of Their Children*, mid-1630s

3

A linguist and diplomat as well as a painter, Peter Paul Rubens was easily the most celebrated artist of his time. Although at home in Antwerp and a favorite of the Habsburgs at Brussels, Rubens also worked in Rome, Genoa, Paris, London, and Madrid. He was, above all, a public painter, in service to royal courts and the Catholic Church. His efficient studio turned out altarpieces and large canvases treating historical, allegorical, and mythological themes as well as hunting scenes. Rubens's younger colleague Anthony van Dyck, working in Antwerp and in London at the court of Charles I (ruled 1625–49), became the premier portraitist in northern Europe. His gracious and fluid manner was influential for the next 150 years, culminating in the canvases of Sir Joshua Reynolds and Thomas Gainsborough.

British 18th-Century Painting

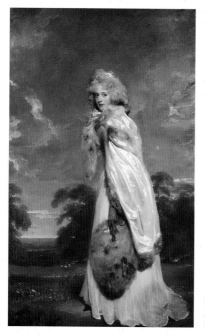

Sir Thomas Lawrence,
*Elizabeth Farren, Later
Countess of Derby*, 1790

The English works exhibited here were painted principally in London but also outside the capital city and date mostly to the 18th century. At first, there was a developing market for landscapes and cityscapes, sporting art, and "conversation pieces," an example of which is William Hogarth's famous wedding picture of 1729, seen in this gallery. In the second half of the century, patrons of all social ranks hungered for ever-larger portraits to give voice to their dynastic standing, individual achievements, or civic ambitions. Thus emerged the lifesize three-quarter- and full-length portraits of Sir Joshua Reynolds, Thomas Gainsborough, and their contemporaries. Sir Thomas Lawrence's vivid images brought this grand-manner tradition to its summit and its end.

English paintings are also on view in the Annie Laurie Aitken Galleries and the English period rooms on the first floor.

Drue Heinz Gallery

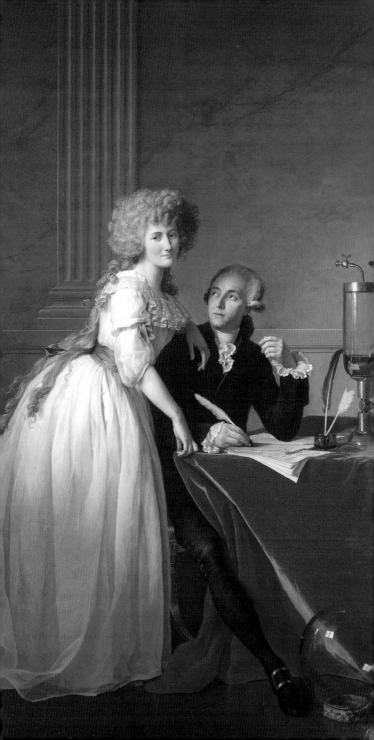

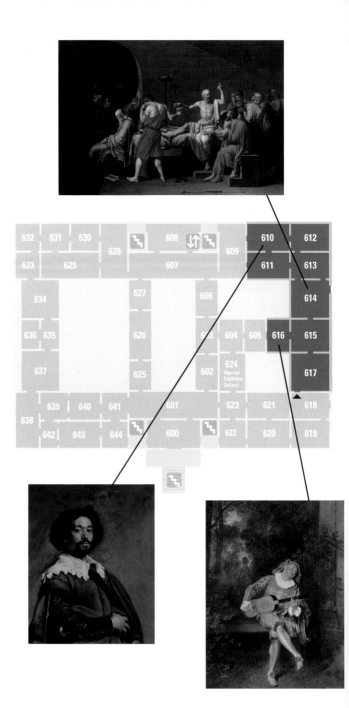

French and Spanish Painting from Poussin to Goya

GALLERIES 610–617

In 17th-century France, Louis XIV's Versailles was the center of court culture. The Académie Royale was founded in 1648, and history painters who participated in its Salons looked to ancient Rome for exemplars and to Nicolas Poussin as their model. In the 18th century, the nobles and wealthier classes preferred the lively atmosphere of Paris, where Antoine Watteau's genre scenes were admired, the fine and decorative arts flourished, and books, music, and theater abounded. The reigns of Louis XV (1723–74) and Louis XVI (1774–92) witnessed not only the Age of Enlightenment and the birth of modern science but also the cataclysmic revolution from which the French empire and the modern democratic state emerged.

4

Under Philip IV (ruled 1621–65), Spain enjoyed a political and cultural golden age. The last of the Habsburgs died in 1700; a war of succession placed the Bourbons on the throne until the early 19th century, when their rule was suspended by the invading armies of Napoleon and a period of violent transition. The transformation of Spanish painting had begun with El Greco, trained in Italy but active in Toledo until 1614. He was succeeded by Diego Velázquez, the supreme portraitist and principal court painter to Philip IV. In Seville Francisco de Zurbarán and Bartolomé Estebán Murillo painted mainly religious works, but also occasional portraits. At the end of this period, Francisco de Goya brought a modern sensibility to deeply revealing portraits of kings, courtiers, and intellectuals.

This visit begins in gallery 617.

French 17th-Century Painting

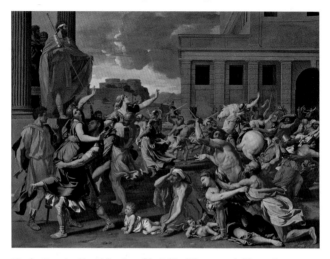

Nicolas Poussin, *The Abduction of the Sabine Women*, probably ca. 1633–34

Louis XIV (ruled 1643–1715) famously declared that he and the State were one and the same ("*L'état, c'est moi*"), but in the 17th century, much of the finest French art was made far from either Versailles or Paris. On view in this gallery, Nicolas Poussin's deeply serious canvases, in which the dramas and tragedies of life are viewed through the lens of ancient Roman literature, were painted in Rome, as were Valentin de Boulogne's gritty soldiers of fortune. Georges de La Tour created his haunting pictures of gypsies and ascetic saints in Lorraine, in northeastern France. Widely admired and collected by French patrons, the work of these artists had a deep and lasting impact on the history of European painting.

History, Portraits, and Genre in 18th-Century France

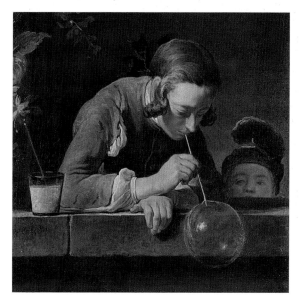

Jean Siméon Chardin, *Soap Bubbles*, ca. 1733–34

4

In France, from 1648 through the 18th century, a painter's training was controlled by the Académie Royale de Peinture et de Sculpture, which was initially sponsored by Louis XIV. Until 1791, only fully qualified academicians and candidates for that status could show in the Salons—the first public exhibitions. Historical, religious, and mythological subjects were favored: a history painter's knowledge of the past, and capacity to interpret it, were thought to confer nobility on the practice of painting, separating the artist from the artisan. Portraits served the essential function of glorifying the monarch and were also commissioned by politicians, society and literary figures, and dancers and singers of the demimonde. Jean Siméon Chardin was a singular exception. A staunch academician, he specialized in still lifes and modest interiors, to which he brought a breathtaking naturalism.

Paris in the Early 18th Century

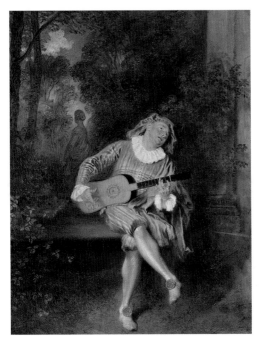

Antoine Watteau, *Mezzetin*, ca. 1718–20

In the final years of Louis XIV's reign and after his death in 1715, the aristocracy abandoned Versailles for the livelier environment of Paris. There, nobles joined wealthy landowners and merchants in clamoring for the pleasures of urban life: the latest book, play, or opera-ballet, or a new house decorated with fine modern paintings and furniture. François Boucher held a preeminent position as the favorite painter of Louis XV's mistress, Madame de Pompadour. Boucher's elegant, highly finished nudes and shepherdesses exemplify an important aspect of official taste, while sophisticated private collectors preferred Antoine Watteau's poignantly lyrical theatrical subjects and the idyllic *fêtes champêtres* of his followers Jean Baptiste Joseph Pater and Nicolas Lancret.

David and Neoclassicism

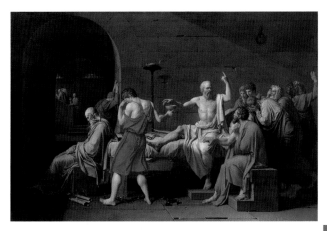

Jacques-Louis David, *The Death of Socrates*, 1787

4

Europe's fascination with the heritage of Greece and Rome assumed new urgency in the years leading up to the French Revolution, the onset of which was marked by the storming of the Bastille prison on July 14, 1789. The roles of artist and political activist converged in Jacques-Louis David. His *Death of Socrates*—a landmark Neoclassical painting—shows the heretical teacher and philosopher of Athens as he prepares to sacrifice his life for his beliefs. The picture was exhibited to acclaim at the Salons of 1787 and 1791. In portraiture during the same period, the accoutrements of courtly power yielded to understated elegance, suggesting a culture of refined intelligence.

Jayne Wrightsman Gallery

The Salon on the Eve of the Revolution

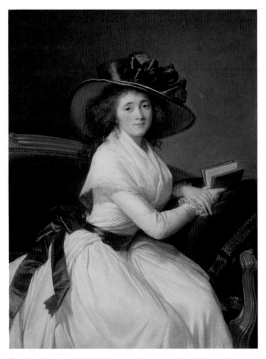

Élisabeth Louise Vigée Le Brun, *Comtesse de la Châtre*, 1789

The pictures in this gallery illustrate the extraordinary level of naturalism and finesse achieved by French portrait painters in the closing decades of the 18th century. This was the moment when the Académie Royale readmitted women, although their numbers were severely restricted and they were still barred from drawing the nude male model, a critical element of academic training. Many women began their careers as miniaturists—from which full-scale portraiture follows naturally—and most, though not all, worked primarily as portraitists. Élisabeth Louise Vigée Le Brun and Adélaïde Labille-Guiard were received into the academy in 1783 and were thus eligible to exhibit at the Salon.

Spanish 16th- and 17th-Century Painting

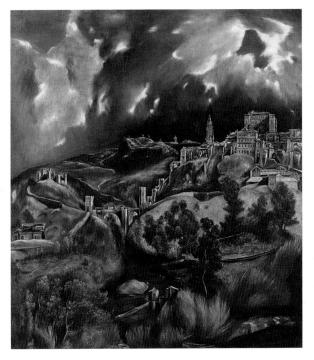

El Greco, *View of Toledo*, ca. 1597–99

Of Greek origin, El Greco trained in Italy and spent most of his life in Toledo, where he developed his unique style. In addition to religious scenes and portraits, he painted a few visionary landscapes, of which the *View of Toledo* is the most famous. The Metropolitan Museum's collection of El Greco's work is the finest outside Spain. His canvases had an enormous impact on 20th-century painters, from Pablo Picasso to Jackson Pollock. By the time El Greco died, in 1614, his ecstatic style had been replaced by a new realism, seen in the work of Francisco de Zurbarán, Jusepe de Ribera, and the young Diego Velázquez.

Spanish 17th-Century Painting

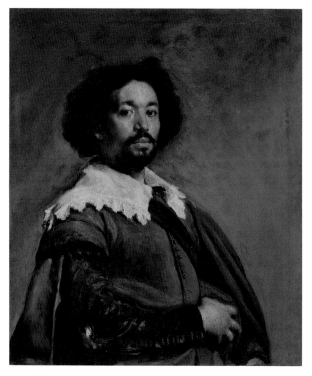

Diego Velázquez, *Juan de Pareja*, 1650

One of the defining geniuses of European painting, Diego Velázquez was the most important artist in 17th-century Spain. His supreme skill as a painter was matched by his knowledge of Italian art, acquired on two trips to Rome, in 1629–31 and 1649–51. The principal court artist to Philip IV (ruled 1621–65), Velázquez was an exceptional portraitist, depicting the king and his family, members of the court, and his own slave and assistant, Juan de Pareja, with the same psychological depth and with consummate bravura. Like Velázquez, Bartolomé Esteban Murillo was from Seville. Instead of moving to the court in Madrid, however, he produced religious paintings in and for his hometown for most of his career.

Goya

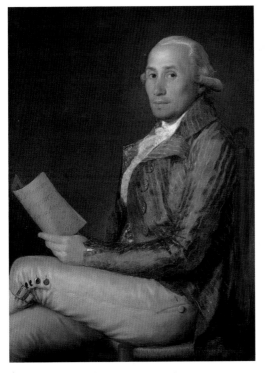

Francisco de Goya, *Sebastián Martínez y Pérez*, 1792

4

In the 18th century, Francisco de Goya was the uncompromising portraitist of the Spanish court as well as of the intellectual elite—a fully engaged observer of his tumultuous times, which saw the collapse of a corrupt monarchy, the wars of independence, the return of the king, and Goya's exile to France. In his work, Goya commented scathingly on the cruelties of war and established a model for the passionate and controversial modern artist. The Metropolitan's collection of his portraits is of exceptional quality, ranging in time from 1787–88 (the charming portrait of the Count of Altamira's young son, Manuel Osorio) to 1820 (the warm and direct depiction of Tiburcio Pérez, an architect and the painter's close friend).

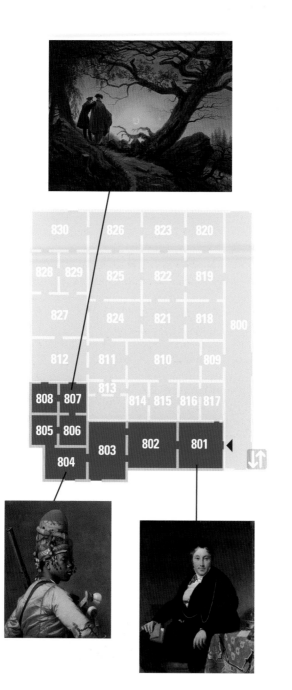

Ingres, Delacroix, Turner: French, British, and Northern Painting

GALLERIES 801–808

The years between roughly 1800 and 1850 saw upheavals in Europe: the rise of Napoleon and his defeat at Waterloo by the Duke of Wellington, the restoration of the monarchy in France, and widespread popular uprisings in 1848. National identities were forged and borders redrawn. Such was the backdrop for an era of remarkable artistic innovation. Genres from history painting to portraiture acquired fresh potency, whether in the vibrant palette and free brushwork of Eugène Delacroix or the clear, disciplined line of J.-A.-D. Ingres. Landscape painting flourished in works as varied as J. M. W. Turner's quasi-abstract seascapes and Camille Corot's hazy visions of rivers and glades in France. Contemporary everyday life gained new resonance as a pictorial subject, while, at the same time, a spirit of adventure prevailed, sending artists back and forth across the English Channel and to Italy, North Africa, and Asia Minor in search of inspiration. The art of this period paved the way for the modern movements that followed.

5

This visit begins in gallery 801.

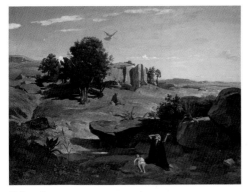

Gallery 803

Neoclassicism and Romanticism

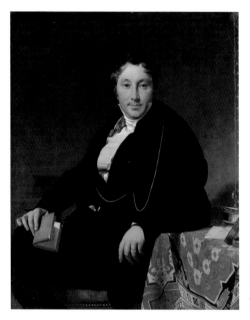

Jean-Auguste-
Dominique Ingres,
*Jacques-Louis
Leblanc*, 1823

Two tendencies, the Neoclassical and the Romantic, dominated
French art in the first half of the 19th century. The Classicists
looked to the work of J.-A.-D. Ingres, with its incisive line and
serene grandeur, while the Romantics rallied around Théodore
Gericault, who infused classical sensibilities with overtones of
melancholy and violence, and Eugène Delacroix, who invigorated
history painting with dynamic color and brushwork. Although
Neoclassicism and Romanticism were generally considered to be
fiercely opposed, they frequently overlapped in subject matter
(as in Delacroix's penchant for Greco-Roman themes) and even
in approach: the brilliant hues of Ingres's portraits hardly fit the
stereotype of Neoclassical restraint. These painters, and the
styles they championed, were enduring touchstones for later
French artists, from Edgar Degas to Henri Matisse.

The André Meyer Galleries

Barbizon School

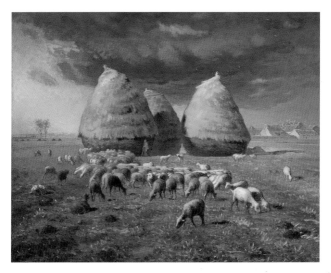

Jean-François Millet, *Haystacks: Autumn*, ca. 1874

This gallery features works by the artists known collectively as the Barbizon School. Beginning in the 1820s, many of France's leading landscape painters made regular excursions to the Forest of Fontainebleau, southeast of Paris. With the village of Barbizon as their base, they set about depicting the forest's richly varied terrain. Théodore Rousseau's paintings of rugged woodlands and grassy meadows convey the magnificent unruliness of nature—a Romantic ideal given expression previously by Théodore Gericault. Jean-François Millet was drawn to the rustic, dignified life of peasants. Millet's paintings of humble farm laborers have an urban counterpart in Honoré Daumier's unsentimental portrayals of working-class Parisians. The efforts of these artists represent a major step in the establishment of pictorial naturalism in France.

The André Meyer Galleries

Corot

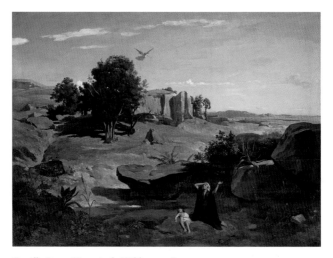

Camille Corot, *Hagar in the Wilderness*, 1835

The Metropolitan owns the largest and most representative body of work by Camille Corot outside France. This gallery presents the full range of his achievements: the limpid Italian views of his younger years; the grand history paintings of his maturity, in which nature is a stage for human drama; his figure paintings, with grave yet graceful studio models who recall the works of the Renaissance masters Raphael and Leonardo; and late scenes of the countryside around his home in Ville-d'Avray, west of Paris, veiled in silvery mists. Corot's art played a pivotal role in the transition from Neoclassicism, which reconfigured nature as an eternal ideal, to Impressionism, which sought to convey a quality of ephemeral, shimmering life.

Janice H. Levin Gallery

European Vision of North Africa

Jean-Léon Gérôme,
Bashi-Bazouk,
1868–69

5

In 1798 Napoleon conquered Egypt, which had been a province
of the Ottoman Empire since 1517. Although he was driven out
by the British after one year, his campaign unleashed in Europe a
profound fascination with the Orient and Islamic culture. Artists
crossed the Strait of Gibraltar to Africa and roamed as far as Syria
and Turkey in search of exotic landscapes and picturesque scenes
of daily life; they returned home not only with the artworks they
had produced abroad but also with costumes and accessories in
which they attired their studio models. This gallery displays
works by several generations of artist-travelers, including Jean-
Léon Gérôme. His canvases, with their meticulous detail and
saturated color, conjure a vision of North Africa and Asia Minor
that captivated European and American audiences.

Kenneth Jay Lane Gallery
Henry J. Heinz II Galleries

Plein-Air and Northern Landscapes

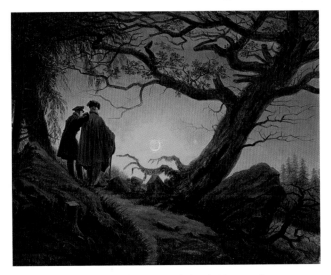

Caspar David Friedrich, *Two Men Contemplating the Moon*, ca. 1825–30

About 1800, landscape painting assumed a new importance as artists increasingly sought to transcribe their responses to nature more directly, by working out of doors (*en plein air*). These three galleries give a rich overview of the practice, which took hold in the early 19th century and laid the groundwork for the subsequent innovations of the Romantics, Realists, and Impressionists. Painters explored the countryside throughout Europe, but Rome, with its historical associations, remained a favorite destination. The broad range of approaches to landscape may be seen in works extending from François-Marius Granet's classic view *Ponte San Rocco and Waterfalls, Tivoli* to Caspar David Friedrich's evocation of nature as a spiritual realm in *Two Men Contemplating the Moon*.

Henry J. Heinz II Galleries

British 19th-Century Painting

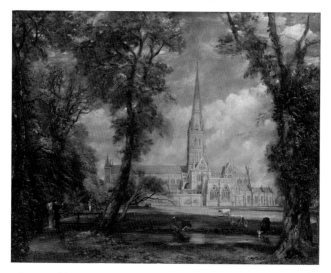

John Constable, *Salisbury Cathedral from the Bishop's Grounds*, ca. 1825

For much of the 19th century, British art was a powerful stimulus to painters throughout Europe. In no area was Great Britain more influential than in landscape. The lively brushwork, sparkling light, and realistic detail found in John Constable's scenes of rural England—which caused a sensation at the Paris Salon of 1824—spurred artists to depict their native scenery with new directness. J. M. W. Turner's dramatic, sometimes nearly abstract, evocations of sea, air, and sky inspired painters as diverse as Eugène Delacroix and Claude Monet to portray the fleeting effects of nature in their work. A similar frankness and vigor animate British figure painting of the period, which is often rooted in contemporary life.

5

Henry J. Heinz II Galleries

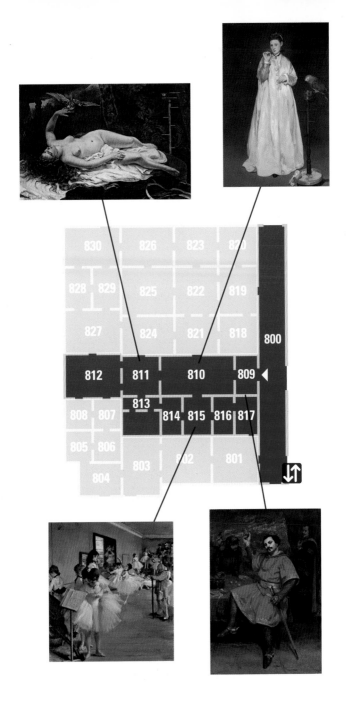

830 826 823 820

828 829 825 822 819

827 824 821 818

800

812 811 810 809 ◄

813

808 807 814 815 816 817

805 806

804 803 802 801

Courbet, Manet, Degas: 19th-Century Paintings and Pastels

GALLERIES **800, 809–817**

Gustave Courbet, Édouard Manet, and Edgar Degas were among the most innovative and influential figure painters in 19th-century France. They came of age in a prosperous, forward-looking era, which was nonetheless marred by simmering social tensions as French citizens strove for democratic reform. At mid-century, Courbet, followed by Manet and Degas, carried this insurgent spirit into art. Each reappraised art-historical tradition, rejecting academic pomp and polish in favor of scenes that expressed the gritty realities of the modern age. As much as the three men differed in temperament and style, their shared commitment to representing their era directly, and in their own terms, blazed a trail for a generation of "painters of modern life." Puvis de Chavannes, too, went against the grain in his lyrical portrayals of antiquity. The austere poetry of his paintings inspired many artists around the turn of the century.

This visit begins in gallery 809.

Gallery 800

6

Courbet's Portraits

Gustave Courbet,
*Louis Gueymard as
Robert le Diable*, 1857

Gustave Courbet aimed "to be in a position to translate the customs, the ideas, the appearance of my epoch, according to my own estimation." Portraits were central to his goal of depicting contemporary life with forthright directness, an aesthetic known as Realism. This gallery, hung with paintings from the 1850s and 1860s, when Courbet's career was at its peak, reveals him at his most versatile and inventive. In likenesses of his intimate circle and in commissioned works, he adapted a wide range of sources—including Renaissance portraiture, modern studio photography, and fashion plates—to convey the distinctive look and temperament of his sitters, who ranged from dashing singers to demure, upper-class wives. Courbet's portraits demonstrate the probing observation and theatrical flair that defined his artistic approach.

Manet

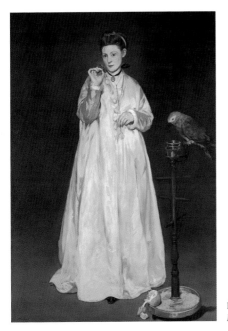

Édouard Manet, *Young Lady in 1866*, 1866

In the early 1860s, Édouard Manet turned tradition on its head, boldly restaging themes from the old masters in contemporary terms, with studio models posing as mistresses and toreadors. Critics were disconcerted not only by the artist's subject matter but also by his simplified modeling and abrupt tonal contrasts. Manet's good friend Edgar Degas shared his commitment to painting modern life, employing daring compositional arrangements to fix his sitters in unguarded moments. (Galleries 814–817 display a full complement of Degas's work.) The two pioneering artists were regarded as the harbingers of the New Painting, now known as Impressionism. The Metropolitan was the first museum in the world to acquire paintings by Manet (via gift in 1889) and today has the most important collection of large-scale paintings by Manet and Degas outside France.

6

Courbet

Gustave Courbet, *Woman with a Parrot*, 1866

Gustave Courbet outraged the Parisian art world in the early 1850s
with paintings of everyday life in the French provinces. In the
late 1850s and 1860s, he channeled his passion for unembellished
realism into different genres. The artist, an avid hunter, made
a series of pictures that hone in on the drama of pursuer and
pursued, playing off eager sportsmen and their dogs against the
mortal beauty of their prey. Courbet also turned heads with his
superbly physical paintings of female nudes, in which the
specificity of detail—a suntanned arm, the waistband of a skirt—
reveals the women to be actual, individual models rather than
bland idealizations. Courbet remained a controversial figure,
but not at the expense of popular and commercial success.

Courbet, Daubigny, and Bonheur

Gustave Courbet, *Young Ladies of the Village*, 1851–52

When Gustave Courbet exhibited *Young Ladies of the Village* at the Paris Salon of 1852, critics denigrated his portrayal of middle-class country girls; the monumental format and serious tone of the painting were generally reserved for historical subjects. This scene defined Courbet's style and cemented his reputation as a convention-breaking provocateur. In landscapes and seascapes depicting his native region of Franche-Comté and the Normandy coast, thick impasto conveys the tactility of rough sand, churning water, and jagged rock. Courbet's earthy manner contrasts with the flickering brushwork of his contemporary Charles-François Daubigny, known for the striking simplicity of his landscape motifs. Nature takes on a nobler cast in the work of Rosa Bonheur. One of the few female animal painters of her time, Bonheur made her mark with large, rousing scenes such as *The Horse Fair*.

6

Henry J. Heinz II Galleries

Fin-de-Siècle Art and Design

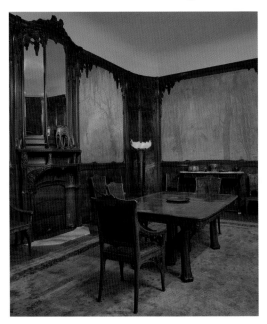

Lucien Lévy-Dhurmer, Wisteria Dining Room, 1910–14

In the last decades of the 19th century, a new sensibility embracing the otherworldly visions of Symbolism and Art Nouveau emerged in European art. Odilon Redon's still lifes were based on nature, many of the flowers having been cut from Redon's own garden, but his sinuous harmonies evoke the realms of imagination and poetry. A similar penchant for ethereal effects can be seen in the work of Lucien Lévy-Dhurmer, who designed a botanically inspired dining room for the Paris apartment of Auguste Rateau, an engineer and art connoisseur. The ensemble, known as the Wisteria Dining Room, is the only complete French Art Nouveau interior in an American museum.

Degas's Paintings and Sculptures

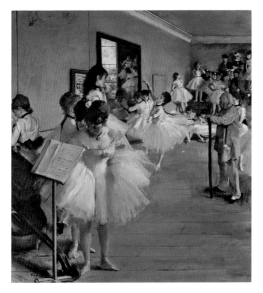

Edgar Degas, *The Dance Class*, 1874

Four galleries, three of them named in honor of Louisine and
H. O. Havemeyer, display the Museum's comprehensive collection
of works by Edgar Degas. The artist's contemporaries justly
described him as "infatuated with modernity." In boldly cropped,
asymmetrical compositions characterized by unusual vantage
points and studiously casual poses, he portrayed the people of
his time. His genre scenes and portraits capture the psychological
subtleties of facial expression, dress, and setting. Drawn to the
theater and ballet, he also investigated the form and movement
of the human body in paintings, drawings, and pastels, and in
sculptures, originally modeled in wax and largely intended as
private exercises. Degas never fully embraced the Impressionists'
plein-air approach; he executed his works in the studio, basing them
on meticulous sketches done from life. But he was nonetheless
central to the Impressionist movement, both for his subject
matter and as a principal organizer of the group's exhibitions.

The Havemeyer Galleries

Degas's Paintings and Pastels

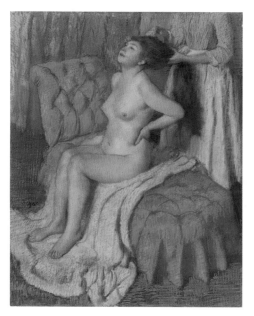

Edgar Degas, *Woman Having Her Hair Combed*, ca. 1886–88

About 1875, pastel enjoyed a resurgence in France. Inspired by the velvety delicacy of 18th-century pastel portraits, artists from Édouard Manet to Henri de Toulouse-Lautrec took up colored chalks in a spirit of experimentation, creating vibrant scenes of modern life. Foremost among pastel's aficionados was Edgar Degas. In the mid-1870s, he began to explore the medium in earnest, diluting his chalks, mixing them with other materials, overlaying tints, and varying his strokes to create densely textured works. Degas applied his techniques to a host of contemporary subjects, notably female bathers. His images of women engrossed in their toilette show the body in a newly intimate light—sometimes ungainly, sometimes graceful, never less than provocative. The candor of these images finds an echo in Lautrec's oil sketches of the tawdry nightlife of Montmartre.

The Havemeyer Galleries (814–816)

Puvis de Chavannes and Rodin

Pierre Puvis de Chavannes, *The Shepherd's Song*, 1891

This gallery is dedicated to sculptures by Auguste Rodin and Antoine-Louis Barye and to large-scale paintings, including works by Puvis de Chavannes, who appropriated the fresco traditions of ancient Rome and the Renaissance to create murals for scores of public buildings in France. His serene, dreamlike scenes proved a revelation to younger artists such as Paul Gauguin and Georges Seurat, who were in search of alternatives to naturalism. Another of Puvis's admirers was Rodin, who brought a frank new physicality and sensuality to sculpture of the human figure. As a young man, Rodin studied under Barye, whose bronzes of wild animals epitomize his era's fascination with untamed nature. The main proving ground for Puvis and his contemporaries was the Paris Salon, a high-profile, state-sponsored, annual or biannual exhibition of contemporary art. Pictures in the grand manner were favored at the Salon.

6

B. Gerald Cantor Sculpture Gallery

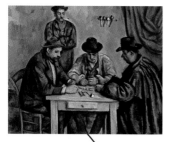

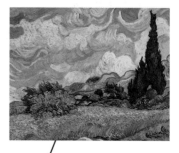

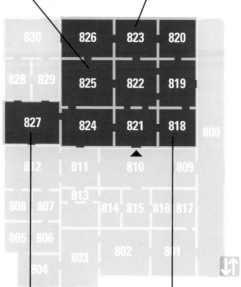

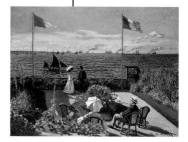

Monet, Cézanne, Van Gogh: Impressionism and Post-Impressionism

GALLERIES 818–827

The proliferation of styles and fresh initiatives that defined late 19th-century art took root in Paris in the years just before and after the Franco-Prussian War (1870–71). Harnessing the lessons of Courbet and Manet, a group of like-minded artists staged a series of independent exhibitions between 1874 and 1886. These groundbreaking presentations launched the Impressionist movement and the style championed by Claude Monet, as well as the careers of Paul Cézanne and Paul Gauguin. The Impressionists rejected the lofty subjects and slick finish of academic painting, endeavoring to capture the rhythm of contemporary life with lively color and brushwork. In the mid-1880s, as the Post-Impressionists entered the fray, naturalism yielded to greater formal invention, opening the way for early modernism (featured in galleries 828–830 and beyond).

This visit begins in gallery 821.

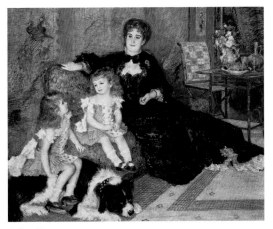

Gallery 824

7

The Annenberg Collection: 19th- and 20th-Century Masters

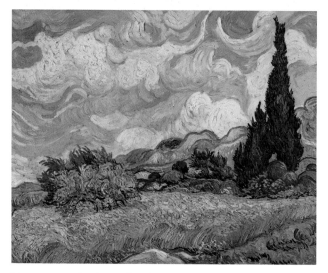

Vincent van Gogh, *Wheat Field with Cypresses*, 1889

This suite of galleries features the collection assembled by Walter H. and Leonore Annenberg from the early 1950s to the early 1990s. It includes more than fifty works by eighteen of the most renowned artists working in France during the 19th and early 20th centuries. By the terms of the bequest, the collection is exhibited together. While the organization of the surrounding rooms is largely monographic and chronological, in the three rooms devoted to the Annenberg Collection, key examples by different artists hang close to one another: Claude Monet alongside his mentor, Eugène Boudin; Pablo Picasso across from one of his idols, Henri de Toulouse-Lautrec; Henri Matisse near his early inspirations Paul Gauguin and Vincent van Gogh. Related works by Impressionist and Post-Impressionist artists may be seen in adjacent rooms.

The Annenberg Galleries

Early Monet

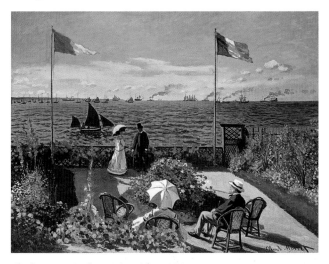

Claude Monet, *Garden at Sainte-Adresse*, 1867

Long regarded as the quintessential Impressionist, Claude Monet often claimed that the open air was his only studio. Introduced to the joys of painting outdoors by Eugène Boudin in the 1850s, Monet debuted on the Paris art scene in the 1860s with crisply rendered scenes of modern life that depended on inventive compositions (many inspired by Japanese woodblock prints), broken brushwork, and high-keyed color to capture the pulse and flux of the world around him. In the 1870s, he trained his gaze more exclusively on landscape. Painting in and around Paris, along the Seine, and on the coast of Normandy, he responded to the changing face of nature with quick strokes of color that conveyed the immediacy of his direct impression.

7

The Annenberg Galleries

Monet: Mid- to Late Career

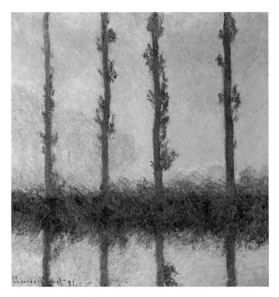

Claude Monet, *The Four Trees*, 1891

By the middle of his career, Monet was working in series to evoke, in successive images, the vital essence of things seen under variable light and weather conditions. Painting on the spot and fine-tuning his canvases in the studio, he ensured the integrity not only of his direct impression—whether it be of haystacks in a field, poplars along a river, or the stony facade of Rouen Cathedral—but also of his larger vision, which extended to the harmony of the whole. In turn, the fleeting moments he arrested in paint acquired a timeless resonance. Over time, he intensified and broadened his painting campaigns in series that tackled the coastlines of Normandy and the Mediterranean as well as urban waterways, from the Thames to the Grand Canal. During his last decades, he turned almost exclusively to the gardens he cultivated at Giverny, creating mural-sized canvases of water lilies in a fluid style that verges on abstraction.

The Annenberg Galleries

Pissarro

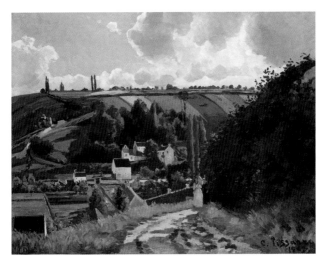

Camille Pissarro, *Jalais Hill, Pontoise*, 1867

Camille Pissarro came into his own by carrying forward the
innovations of Corot, Courbet, and Daubigny in views of the
working countryside that were admired by his contemporaries
for their sincerity and truth to nature. He was already known for
this subject matter when he adopted an Impressionist style in the
1870s. In the 1880s, he gave greater prominence to the human
form in paintings of peasants that reflected his leftist political
sympathies. Ever open to experimentation, Pissarro, in the
middle of that decade, embraced Georges Seurat's divisionist
technique as a novel means of achieving compositional structure.
In the 1890s, inspired by Claude Monet, Pissarro returned to
Impressionist methods with series of bustling cityscapes and
harbor scenes. As the elder statesman of the Impressionists,
Pissarro—the only artist to participate in all eight of their
exhibitions—served as a mentor and collaborator to his fellow
painters, including Paul Cézanne and Paul Gauguin.

7

The Annenberg Galleries

Post-Impressionism

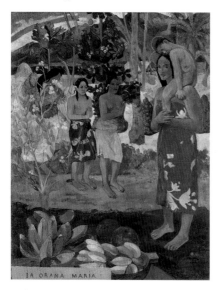

Paul Gauguin, *Ia Orana Maria* (*Hail Mary*), 1891

Commonly referred to as Post-Impressionists, these artists
departed from Impressionism by developing individual forms
of expression that opened up a new range of picture-making
possibilities, from Georges Seurat's rigorous divisionist (pointillist)
technique to the expressive verve of Vincent van Gogh's loaded
brush. Along with Paul Cézanne, they sought to infuse art with
greater weight and substance, relying on color, line, and form to
distill, intensify, or suspend visual reality. Seurat's approach
attracted followers in France and Belgium and found its greatest
champion in Paul Signac. Paul Gauguin cultivated a circle of
"disciples" among his fellow artists in Brittany and the Paris-
based painters called the Nabis before setting sail to discover
the "mysterious center of thought" in Tahiti. Van Gogh largely
worked away from the mainstream, in Holland and later in
France, where his art came fully into its own.

The Annenberg Galleries

Cézanne

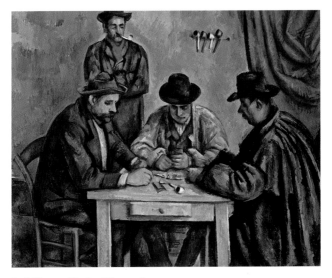

Paul Cézanne, *The Card Players*, 1890–92

Paul Cézanne left his mark on all the major artistic movements of his time. His early portraits, densely painted in dark hues, combine the intensity of Romanticism with the assertive materiality of Courbet and Manet. With the advent of Impressionism in the 1870s, Cézanne became newly attuned to the play of light and color, but in his work, the transient sensations beloved of the Impressionists yielded to a probing investigation of nature's structure and geometry. He developed a unique painting style, employing "constructive" strokes of modulated color, rather than line and shading, to explore the subjects that preoccupied him from the 1880s on: prismatic landscapes set in and around Aix-en-Provence; spatially complex still lifes; and the human figure, ranging from portraits to nude bathers to his famous genre scenes devoted to card players, in which ever-shifting hues play off against the solid monumentality of the sitters' forms.

7

The Annenberg Galleries

Renoir

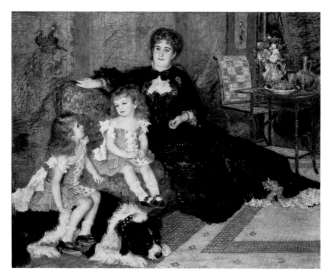

Auguste Renoir, *Madame Georges Charpentier and Her Children*, 1878

Auguste Renoir, a founding member of the Impressionist group, treated all the major themes associated with the New Painting, from urban genre subjects and scenes of modern leisure to landscapes, still lifes, and portraits. His gauzy brushwork and incandescent tones endow his subjects, especially women, with delicacy and sensuality. He once said, "For me a picture—for we are forced to paint easel pictures—should be something likeable, joyous, and pretty—yes, pretty." From about 1880 on, Renoir sought to combine the luminosity of Impressionism with the compositional rigor and ample forms found in classical art and the old masters. Renoir's circle included Henri Fantin-Latour, appreciated for the refined colors of his flower still lifes; Berthe Morisot, who beguiled audiences by weaving Impressionism's airy harmonies into tender scenes of women and families; and Alfred Sisley, whose scintillating landscapes vividly capture the experience of painting out of doors.

The Annenberg Galleries

French Salon Painting

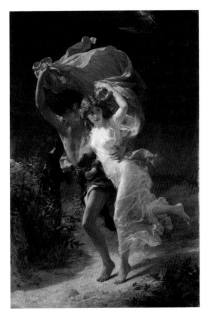

Pierre-Auguste Cot,
The Storm, 1880

The Paris Salon, the official, juried exhibition of the Académie des Beaux-Arts, was a high-stakes arena for French artists for much of the 19th century. A highly successful (or controversial) submission could make a career. Paintings in a style commensurate with the conservative tastes of the Salon—technically pristine, idealized pictures—were often popular and profitable. Idyllic images of women and children, nubile nudes, dramatic mythological or literary subjects, and charming scenes of everyday life found a ready audience among the cosmopolitan upper classes, both in France and abroad. Few were more enthusiastic about Salon art than 19th-century American collectors, including many major benefactors of the Metropolitan. Galvanized by visits to new commercial galleries, wealthy patrons such as Catharine Lorillard Wolfe and her cousin John Wolfe filled their homes, and eventually the Museum, with premier examples of the most sought-after and fashionable paintings of the day.

Henry J. Heinz II Galleries

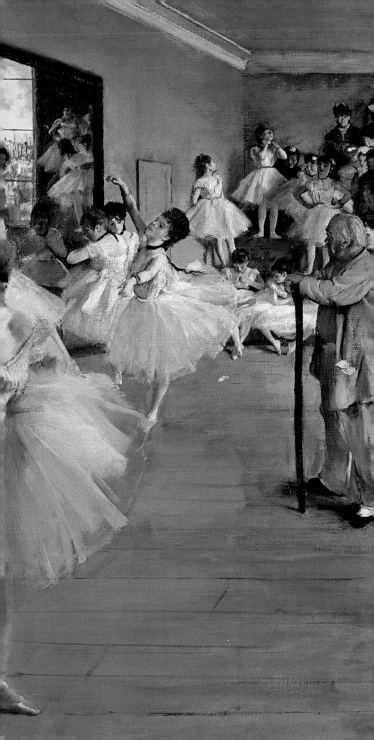

A Summary History of the Department of European Paintings

A CHRONOLOGY

The Metropolitan Museum of Art's Department of European Paintings has benefited and continues to benefit from the generosity of those whose names appear in the credit lines that accompany all publications and displays of works of art. Below is a summary history of the most significant donations, both of paintings and of purchase funds, in the department's history. Many other donors have made extraordinary gifts and promised gifts of pictures or have contributed to the acquisition of important works. These individuals maintain the great tradition of philanthropy in New York and enable the Museum to continually improve and rethink its presentation of the history of Western painting.

1871
174 old master paintings purchased in Belgium and France

1887
Bequest of Salon paintings from New York philanthropist Catharine Lorillard Wolfe, together with an endowment, with which the Museum later purchases David's *Death of Socrates*, Delacroix's *Abduction of Rebecca*, Ingres's portraits of Monsieur and Madame Leblanc, and Renoir's *Madame Georges Charpentier and Her Children*. Other gifts: Rosa Bonheur's *The Horse Fair*, from Cornelius Vanderbilt, and Meissonier's *1807, Friedland*, from Henry Hilton

1889
Gift of thirty-four works, including Filippo Lippi's *Portrait of a Woman with a Man at a Casement*, Van Dyck's portrait of James Stuart, Duke of Richmond and Lennox, and Vermeer's *Young Woman with a Water Pitcher*, from financier Henry G. Marquand, a trustee and president (1889–1902) of the Museum. Other gifts: Bastien-Lepage's *Joan of Arc* and the first two paintings by Manet to enter any museum (*Young Lady in 1866* and *Boy with a Sword*), from Erwin Davis

1900
Collis P. Huntington's bequest of 19th-century and old master paintings, including Sir Thomas Lawrence's *Calmady Children* and a second work by Vermeer

1901

Bequest of $4.5 million from Jacob S. Rogers, president of Rogers Locomotive and Machine Works in Paterson, New Jersey. Fund's income enables the Museum to acquire such masterpieces as Goya's portrait of Sebastián Martínez y Pérez, in 1906; Bruegel's *Harvesters*, in 1919; Van Gogh's *Cypresses*, in 1949; and Caravaggio's *Musicians*, in 1952. Rogers's example is followed by John Stewart Kennedy, from whose fund the Museum purchases Giotto's *Epiphany*, Veronese's *Mars and Venus United by Love*, and many other works.

1913

Bequest from Benjamin Altman, department store owner, of an outstanding collection notable for Dutch masterpieces by Rembrandt and Hals and important earlier works, including Botticelli's *Last Communion of Saint Jerome*, Memling's portraits of Tommaso and Maria Portinari, and Dürer's *Virgin and Child with Saint Anne*

1915

Bequest from art collector Theodore M. Davis (also a passionate Egyptologist) of works by painters ranging from Giovanni Bellini to Goya and Monet

1916

Gift from J. Pierpont Morgan of the last altarpiece by Raphael in private hands and, the following year, of sixty-two further works, including Memling's *Annunciation* altarpiece

1917

Bequest from Isaac D. Fletcher of his and his wife's art collection and a fund that enables the Museum to acquire Poussin's *Blind Orion Searching for the Rising Sun* in 1924 and Jan van Eyck's *Crucifixion and Last Judgment* diptych in 1933, when the latter is offered for sale by the Hermitage

1929

Mrs. H. O. Havemeyer's bequest of her and her husband's astonishing collection of French 19th-century paintings, formed with guidance from Mary Cassatt. Includes eight works by Corot, eighteen by Courbet, nine by Manet, eight by Monet, and five by Cézanne as well as dozens of paintings, pastels, drawings, and sculptures by Degas. Among the collection's notable old masters are Bronzino (*Portrait of a Young Man*) and El Greco (*Portrait of a Cardinal* and *View of Toledo*).

1931

Bequest from Michael Friedsam, Benjamin Altman's former business partner, of distinguished Renaissance paintings, including Dürer's *Salvator Mundi*

1941

Bequest from German-born investment banker George Blumenthal, a trustee and president (1934–41) of the Museum, of Gothic and Renaissance paintings, including Simone Martini's *Saint Andrew*. Many works had hung in the Vélez Blanco Patio when it was installed in Blumenthal's house on Park Avenue (the patio is now at the Museum; gallery 534).

1949

Official entry into the Museum of the collection of the late Jules Bache, German-born owner of a major brokerage house. Includes Filippino Lippi's *Madonna and Child*, Titian's *Venus and Adonis*, two portraits by Velázquez, Goya's *Manuel Osorio*, and several Fragonards. Other gifts: Manet's *Spanish Singer* and Gauguin's *Two Tahitian Women*, from William Church Osborn, a trustee and president (1941–47) of the Museum; two years later, he bequeathes four paintings, including Monet's *Regatta at Sainte-Adresse*.

1951

Bequest from Museum trustee Sam A. Lewisohn of a superb group of Post-Impressionist pictures, including Seurat's study for *La Grande Jatte*, a still life by Cézanne, Van Gogh's *L'Arlésienne*, and Gauguin's *Ia Orana Maria*

1956

Fund established by Mr. and Mrs. Henry Ittleson Jr. to purchase individual Impressionist and Post-Impressionist paintings, including, in 1962, *Madame Cézanne in a Red Dress*

1960

Bequest from Stephen C. Clark—publisher, founder of the Baseball Hall of Fame, and chairman of the Museum's board—of Impressionist and Post-Impressionist paintings, including *The Card Players* and four other Cézannes, four works by Renoir, and two by Degas

1961

Rembrandt's *Aristotle with a Bust of Homer* acquired at auction by combining various funds and donations

1967
Bequest from Miss Adelaide Milton de Groot, including works by Van Gogh and Lautrec; Monet's *Garden at Sainte-Adresse* acquired at auction by combining various funds

1971
Velázquez's *Juan de Pareja* acquired at auction by combining various funds

1975
Bequest from Museum trustee Joan Whitney Payson of paintings by Manet, Cézanne, Lautrec, Signac, and others. Designated galleries (950–962, on the first floor) are opened to the public for Robert Lehman's huge art collection, bequeathed to the Museum in 1969.

1982
The Jack and Belle Linsky Collection, especially rich in paintings of the 16th through 18th century, presented for display in designated galleries (537–543, on the first floor)

2002
Bequest from Walter H. and Leonore Annenberg of more than fifty works ranging from Corot to Picasso, Impressionist and Post-Impressionist masterpieces, for display in designated galleries (821–823)

2004
Duccio's *Madonna and Child* acquired by combining various funds and donations

1973–2012
Many outstanding paintings given by Mr. and Mrs. Charles Wrightsman, including Georges de La Tour's *Penitent Magdalen*, Vermeer's *Study of a Young Woman*, Rubens's portrait of himself with his second wife and child, and Guercino's *Samson Captured by the Philistines*, as well as the means to purchase, among other works, David's *Antoine-Laurent Lavoisier and His Wife*, Lotto's *Venus and Cupid*, and, in 2012, Gérard's portrait of Talleyrand

Donor Credits

p. 2
65.183.1 Rogers Fund, 1965

p. 8
65.14.3 Gwynne Andrews Fund, and Bequest of Mabel Choate, in memory of her father, Joseph Hodges Choate, by exchange, 1965

p. 9
75.7.2 Gift of Robert Gordon, 1875

p. 10
1995.7 Purchase in memory of Sir John Pope-Hennessy: Rogers Fund, The Annenberg Foundation, Drue Heinz Foundation, Annette de la Renta, Mr. and Mrs. Frank E. Richardson, and The Vincent Astor Foundation Gifts, Wrightsman and Gwynne Andrews Funds, special funds, and Gift of the children of Mrs. Harry Payne Whitney, Gift of Mr. and Mrs. Joshua Logan, and other gifts and bequests, by exchange, 1995

p. 11
14.40.675 Bequest of Benjamin Altman, 1913

p. 12
32.130.2 Purchase, Anonymous Gift, 1932

p. 13
1986.138 Purchase, Mrs. Charles Wrightsman Gift, in honor of Marietta Tree, 1986

p. 14
28.79 Rogers Fund, 1928

p. 15
29.100.16 H. O. Havemeyer Collection, Bequest of Mrs. H. O. Havemeyer, 1929

p. 16
2002.436 Purchase, Lila Acheson Wallace Gift and Gwynne Andrews Fund, 2002

p. 17
32.100.76 The Friedsam Collection, Bequest of Michael Friedsam, 1931

p. 18
49.7.5 The Jules Bache Collection, 1949

p.19
76.10 Gift of J. Bruyn Andrews, 1876

p. 22
1984.459.2 Gift of Mr. and Mrs. Charles Wrightsman, 1984

p. 23
1971.155 Purchase, Bequest of Miss Adelaide Milton de Groot (1876–1967), by exchange, and Dr. and Mrs. Manuel Porter and sons Gift, in honor of Mrs. Sarah Porter, 1971

p. 24
52.81 Rogers Fund, 1952

p. 25
55.119 Fletcher Fund, 1955

p. 26
1988.162 Purchase, Mrs. Charles Wrightsman Gift, 1988

p. 27
1982.438 Purchase, The Charles Engelhard Foundation, Robert Lehman Foundation Inc., Mrs. Haebler Frantz, April R. Axton, L. H. P. Klotz, and David Mortimer Gifts; and Gifts of Mr. and Mrs. Charles Wrightsman, George Blumenthal, and J. Pierpont Morgan, Bequests of Millie Bruhl Fredrick and Mary Clark Thompson, and Rogers Fund, by exchange, 1982

p. 28
1977.1.3 Gift of Mr. and Mrs. Charles Wrightsman, 1977

p. 29
23.128 Anonymous Gift, in memory of Oliver H. Payne, 1923

p. 58
1971.86 Purchase, Fletcher and Rogers Funds, and Bequest of Miss Adelaide Milton de Groot (1876–1967), by exchange, supplemented by gifts from friends of the Museum, 1971

p. 59
06.289 Rogers Fund, 1906

p. 62
19.77.1 Catharine Lorillard Wolfe Collection, Wolfe Fund, 1918

p. 63
60.71.12 Bequest of Lillian S. Timken, 1959

p. 64
38.64 Rogers Fund, 1938

p. 65
2008.547.1 Gift of Mrs. Charles Wrightsman, 2008

p. 66
2000.51 Wrightsman Fund, 2000

p. 67
50.145.8 Bequest of Mary Stillman Harkness, 1950

p. 70
19.84 Gift of Elizabeth Milbank Anderson, 1919

p. 71
89.21.3 Gift of Erwin Davis, 1889

p. 72
29.100.57 H. O. Havemeyer Collection, Bequest of Mrs. H. O. Havemeyer, 1929

p. 73
40.175 Gift of Harry Payne Bingham, 1940

p. 74
66.244.1 Harris Brisbane Dick Fund, 1966

p. 75
1987.47.1 Bequest of Mrs. Harry Payne Bingham, 1986

p. 76
29.100.35 H. O. Havemeyer Collection, Bequest of Mrs. H. O. Havemeyer, 1929

p. 77
06.177 Rogers Fund, 1906

p. 80
1993.132 Purchase, The Annenberg Foundation Gift, 1993

p. 81
67.241 Purchase, special contributions and funds given or bequeathed by friends of the Museum, 1967

p. 82
29.100.110 H. O. Havemeyer Collection, Bequest of Mrs. H. O. Havemeyer, 1929

p. 83
51.30.2 Bequest of William Church Osborn, 1951

p. 84
51.112.2 Bequest of Sam A. Lewisohn, 1951

p. 85
61.101.1 Bequest of Stephen C. Clark, 1960

p. 86
07.122 Catharine Lorillard Wolfe Collection, Wolfe Fund, 1907

p. 87
87.15.134 Catharine Lorillard Wolfe Collection, Bequest of Catharine Lorillard Wolfe, 1887

European Paintings in The Metropolitan Museum of Art: A Walking Guide

Published by The Metropolitan Museum of Art, New York
In association with Scala Publishers Limited

Mark Polizzotti, Publisher and Editor in Chief
Gwen Roginsky, Associate Publisher and General Manager of Publications
Peter Antony, Chief Production Manager
Michael Sittenfeld, Managing Editor

Book design by Miko McGinty Inc.
Director of Publications, Scala Publishers, Jennifer Norman
Edited by Jennifer Bernstein
Project Manager, Amy Pastan
Typeset in Documenta

Text, maps, and photography © 2013 The Metropolitan Museum of Art

Compilation and design © 2013 The Metropolitan Museum of Art and Scala Publishers

Cataloging-in-Publication Data is available from the Library of Congress.
ISBN: 978-1-85759-819-3

Printed in Singapore
10 9 8 7 6 5 4 3 2 1

Photographs of works in the Metropolitan Museum's collection are by Juan Trujillo

Front cover: Johannes Vermeer, *Young Woman with a Water Pitcher*, ca. 1662 (detail). Gift of Henry G. Marquand, 1889 (89.15.21). Gallery 632
Back cover: Vincent van Gogh, *Wheat Field with Cypresses*, 1889 (detail). Purchase, The Annenberg Foundation Gift, 1993 (1993.132). Gallery 823

p. 2: Giovanni Battista Tiepolo, *The Triumph of Marius*, 1729 (detail). Gallery 600; p. 49: Jacques-Louis David, *Antoine-Laurent Lavoisier and His Wife*, 1788 (detail). Gallery 614; p. 88: Edgar Degas, *The Dance Class*, 1874 (detail). Gallery 815

The Metropolitan Museum of Art
1000 Fifth Avenue
New York, New York 10028
metmuseum.org

Scala Publishers Limited
Northburgh Street
10 Northburgh House
London EC1V 0AT

Distributed to the booktrade by Antique Collectors' Club Limited
6 West 18th Street
New York, New York 10011